FUCK OFF

SWEAR WORD COLORING BOOK

The Universe Adult Coloring Book featured with beautiful geometry

By

Florence Clark

Copyright © 2017 by Florence Clark

All rights reserved worldwide. No part of this publication may be reproduced or distributed in any form or by any means, mechanical, electronic or stored in a retrieval or database system, without written permission from the copyright holder.

Happy Coloring!

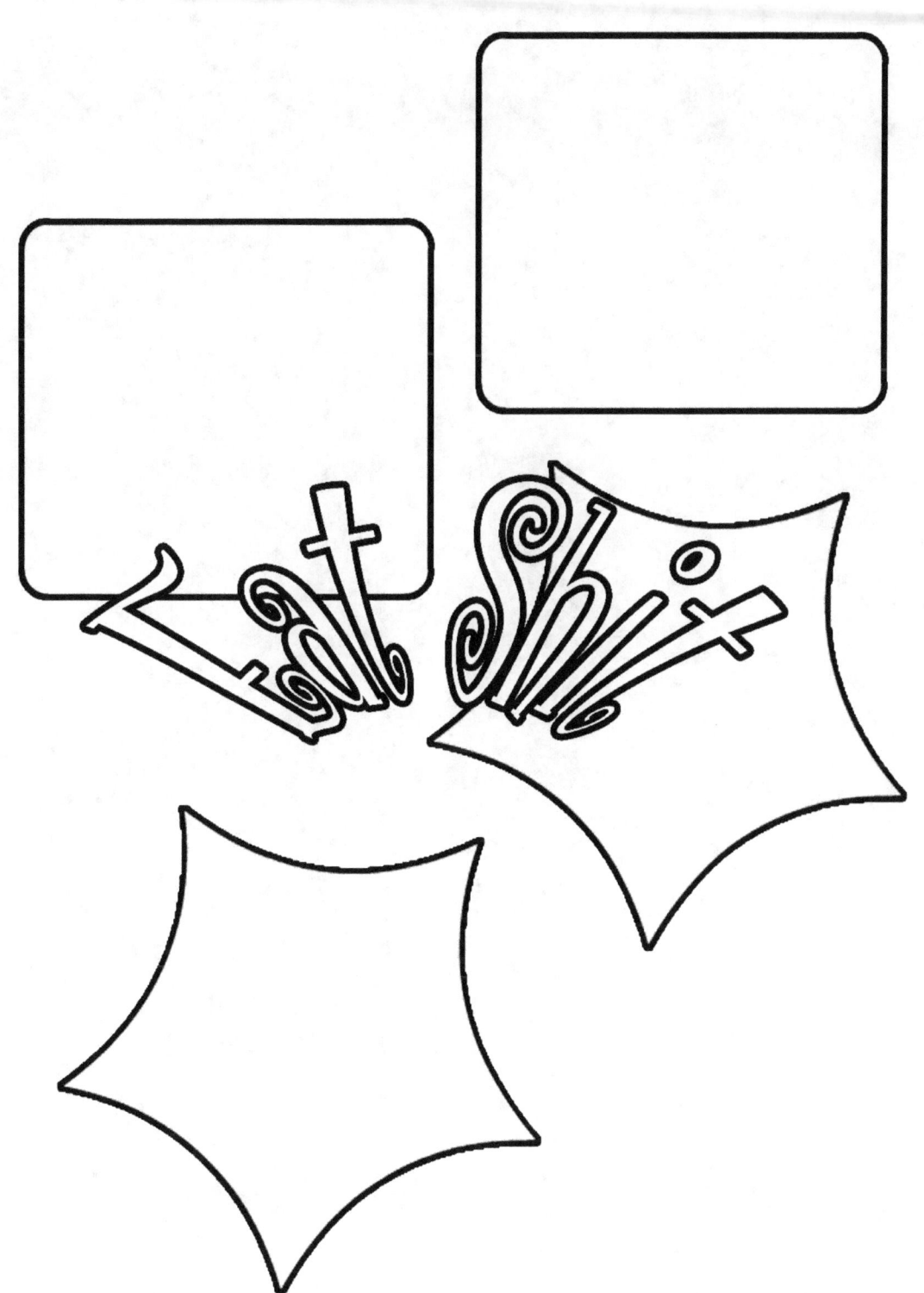

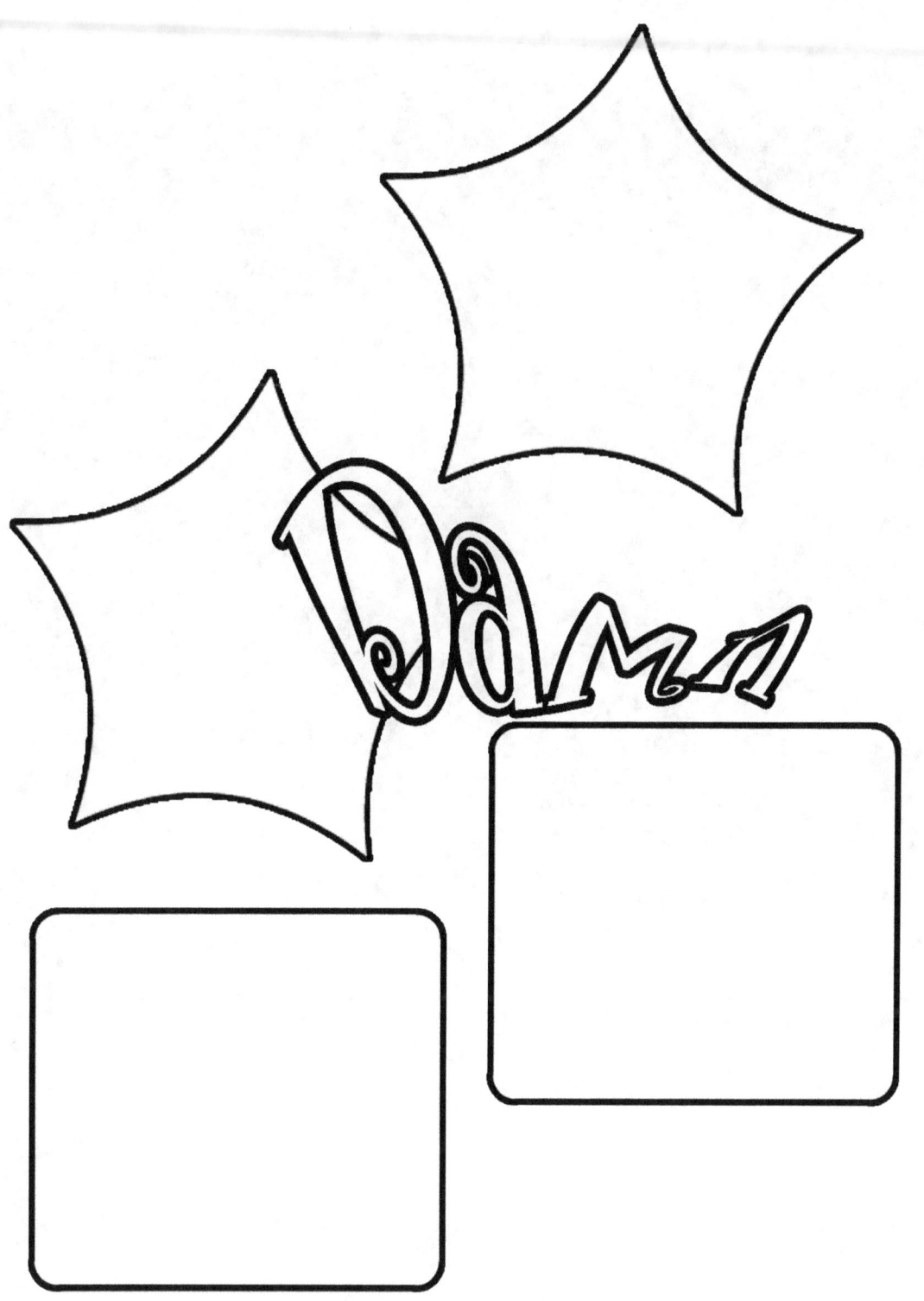

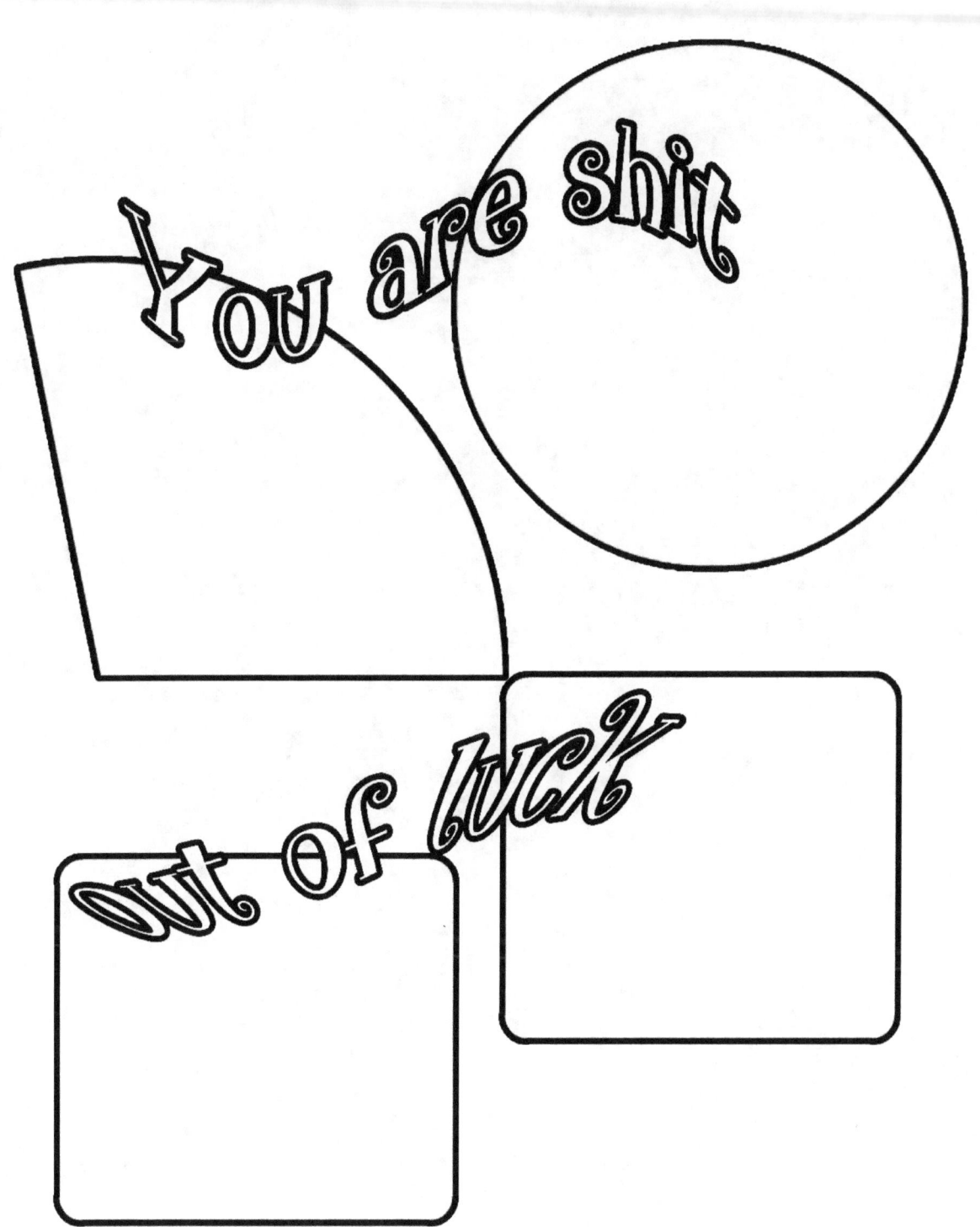

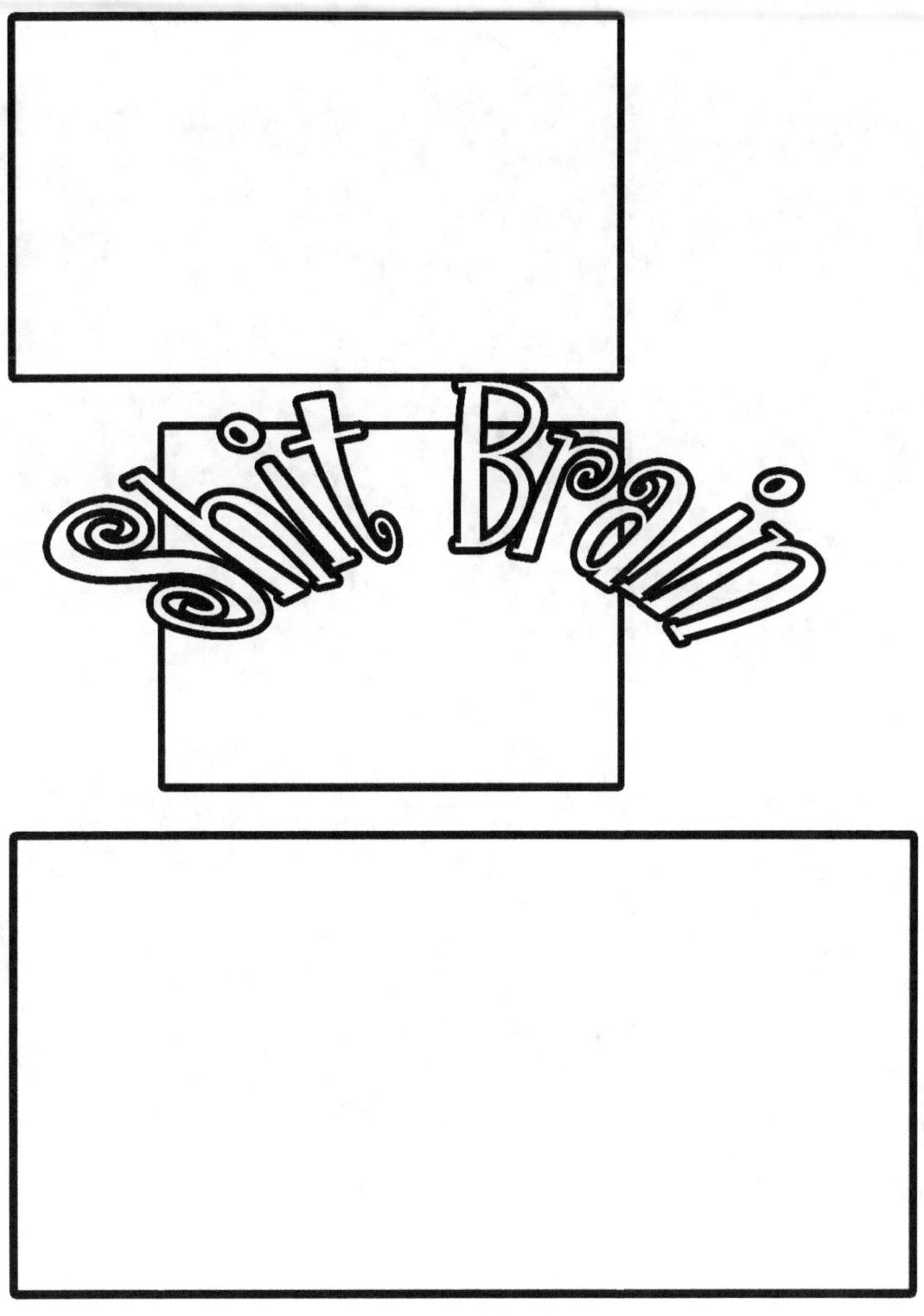

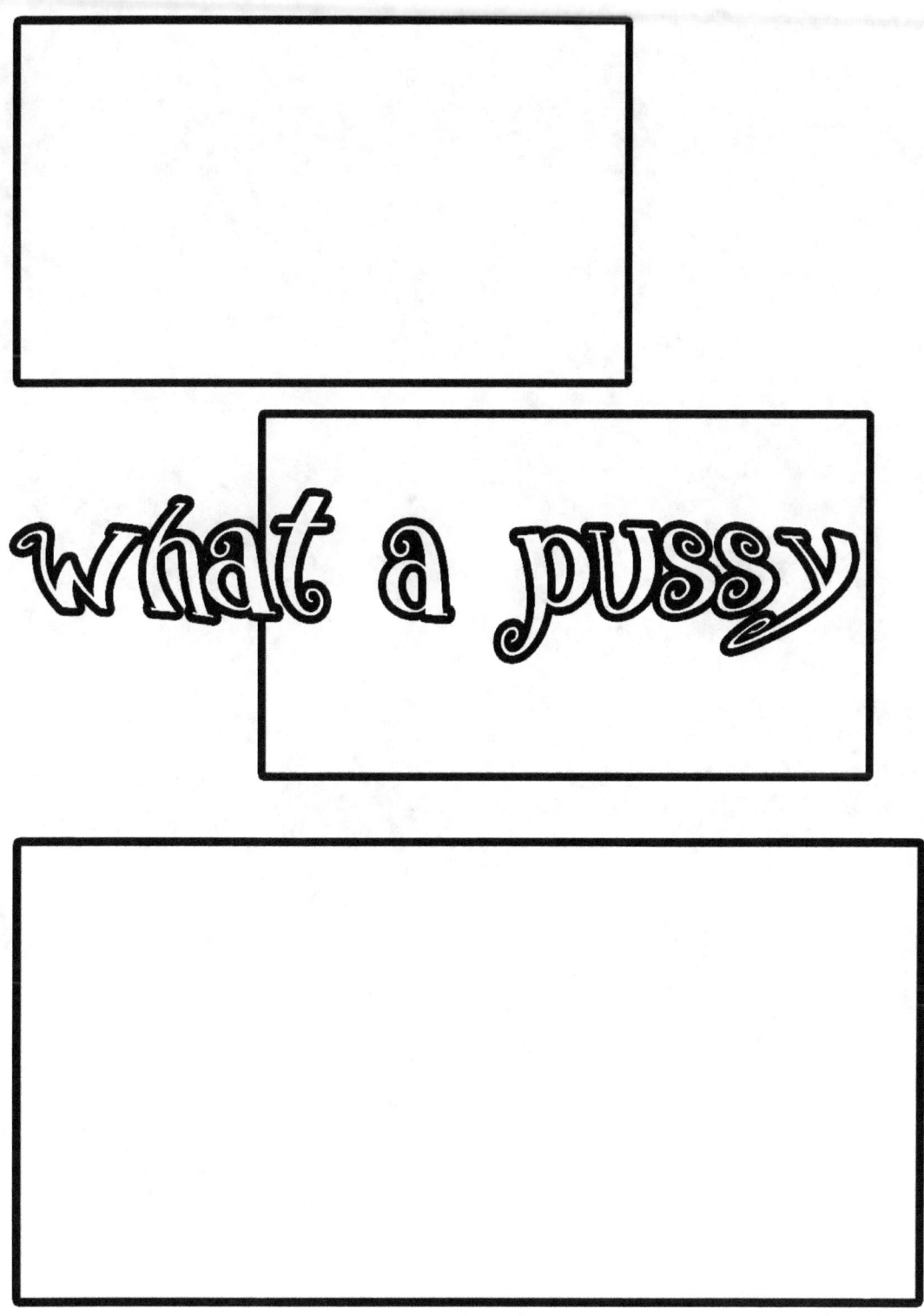

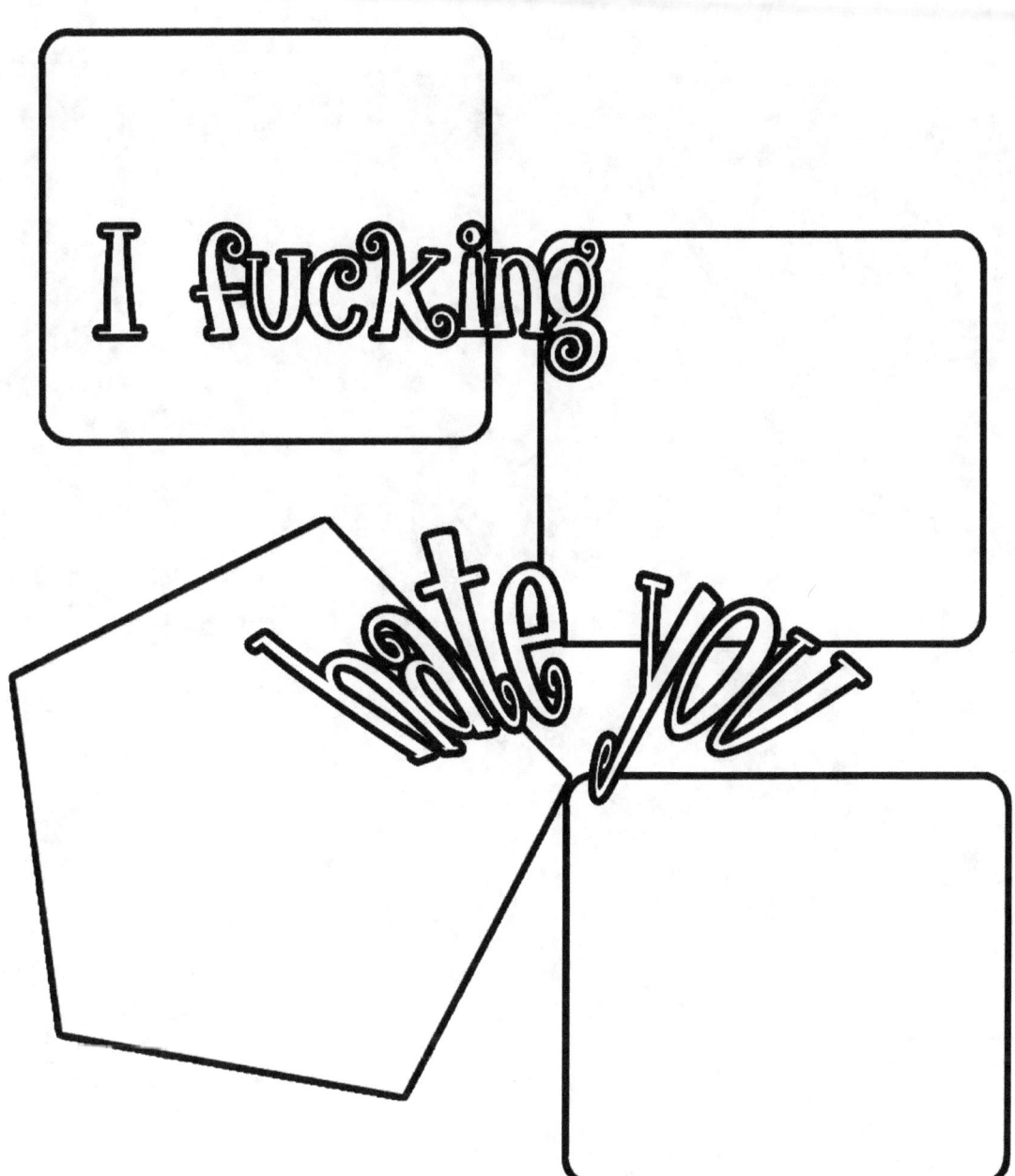

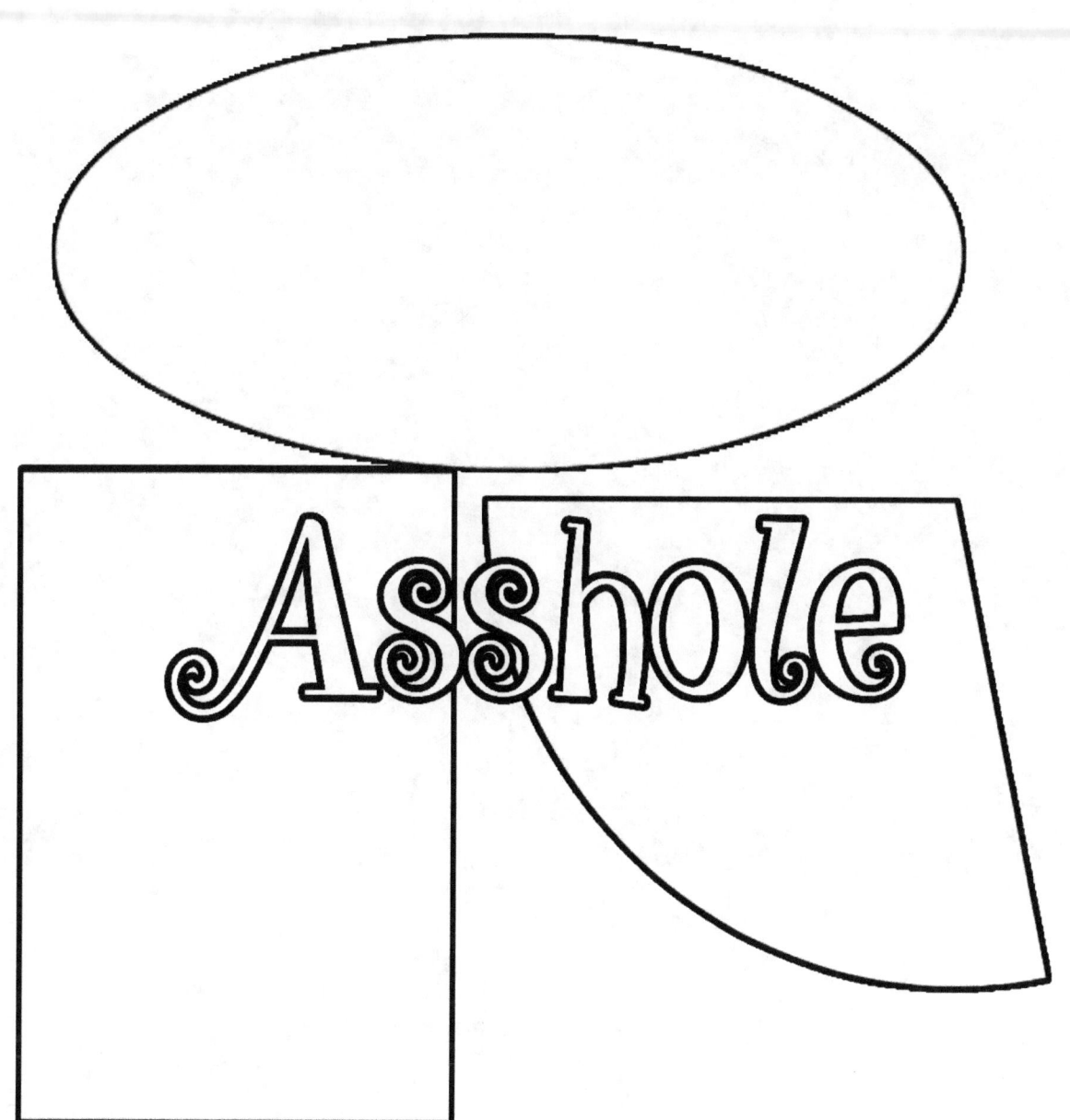

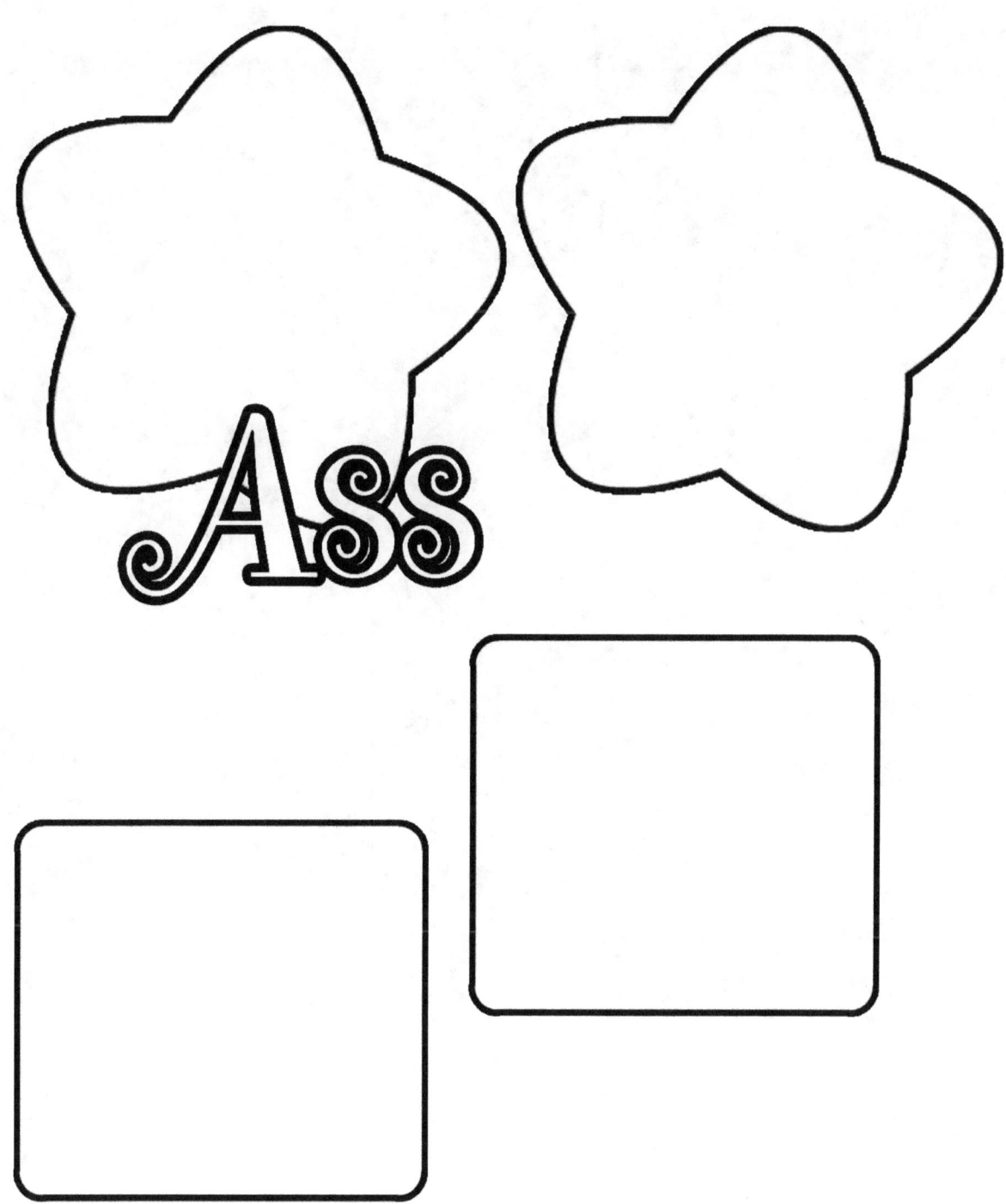

www.ingramcontent.com/pod-product-compliance
Lightning Source LLC
Chambersburg PA
CBHW081129180526
45170CB00008B/3056